THE TAROT GARDEN

Niki de Saint Phalle

PHOTOGRAPHS BY Giulio Pietromarchi

IN 1955 I went to Barcelona. There I saw the beautiful Park Guell of Gaudi. I met both my master and my destiny. I trembled all over. I knew that I was meant one day to build my own Garden of Joy. A little corner of Paradise. A meeting place between man and nature. Twenty four years later I would embark on the biggest adventure of my life, the TAROT GARDEN. It was built in Tuscany on the property of my friends Marella

2

Carlo and Nicola Caracciolo. They had approved the original model which I kept changing. The tarot garden became much bigger than I had originally intended. There was no deadline and I worked in complete freedom. To finance the garden I made a perfume and multiples.

As soon as I started the tarot I realized it would be a perilous journey fraught with great difficulties.

3

I was struck by Rheumatoid
Arthritis and could barely
walk or use my hands.
Yet I went on. Nothing
could stop me. I was bewitched.
I also felt it was my
destiny to make this garden
no matter how great the
difficulties. I made the card
of the Empress my home and
she became the center of the
garden. It was where I met

4

the crew, ate my meals, and made the models for the remaining cards.

I lived alone in the "Sphinx" which is what we nick named the Empress. Total immersion was the only way to realize this garden.

The tarot garden is not just my garden. It is also the garden of all those who

helped me to make it. I am
the Architect of the garden.
I imposed my vision because I
could not do otherwise.

This garden was made with
difficulties, love, wild enthusiasm,
obsession and most of all faith.
Nothing could have stopped me.

As in all fairy tales before
finding the treasure, I met on
my path, dragons, sorcerers, magicians
and the Angel of Temperance.

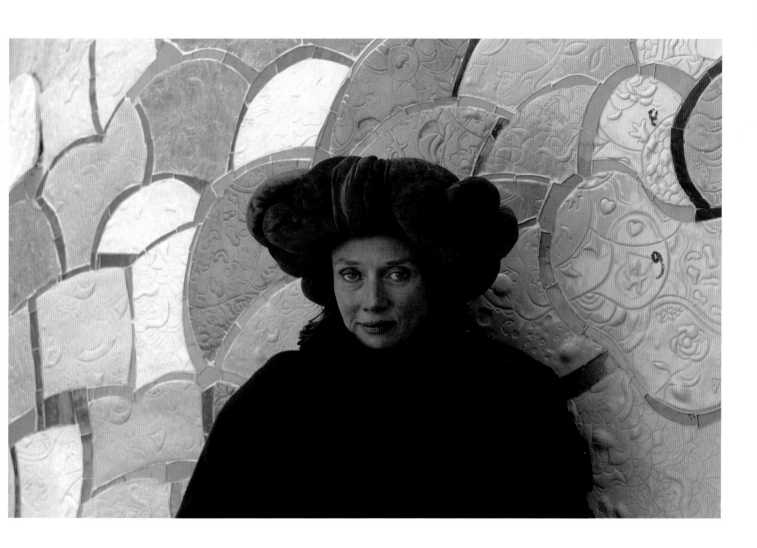

THE MAGICIAN
CARD NO. 1

the great TRICKSTER. FOR
me, the MAGICIAN is the
card of GOD the creator of
the universe. It is HE that
created the marvelous joke
of our paradoxical world.
It is the card of active
intelligence. Pure light, pure
energy, mischief and Creation.

THE HIGH PRIESTESS

CARD NO. II

The High Priestess of INTUITIVE FEMININE POWER.

This FEMININE Intuition is one of the "Keys" of wisdom.

She Represents the irrational unconscious with all its potential. Those who wish to explain events by Reason or logic alone Remain on the surface of things without the depth of instinctual vision and imagination.

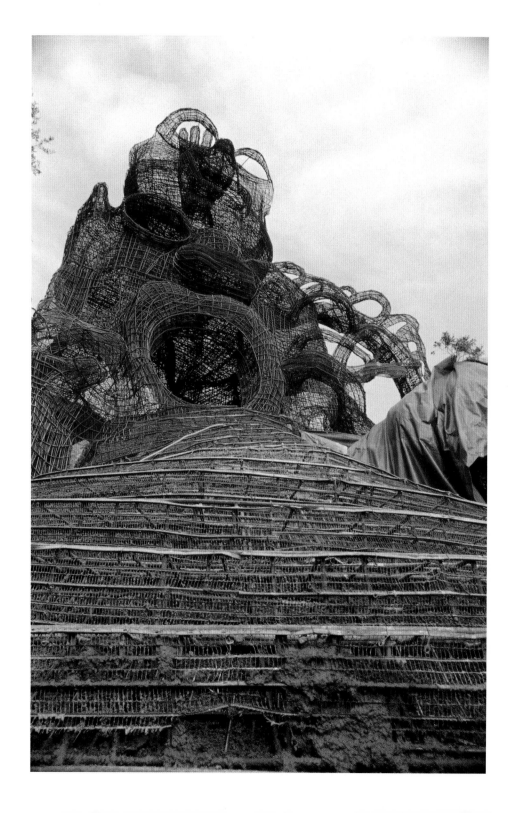

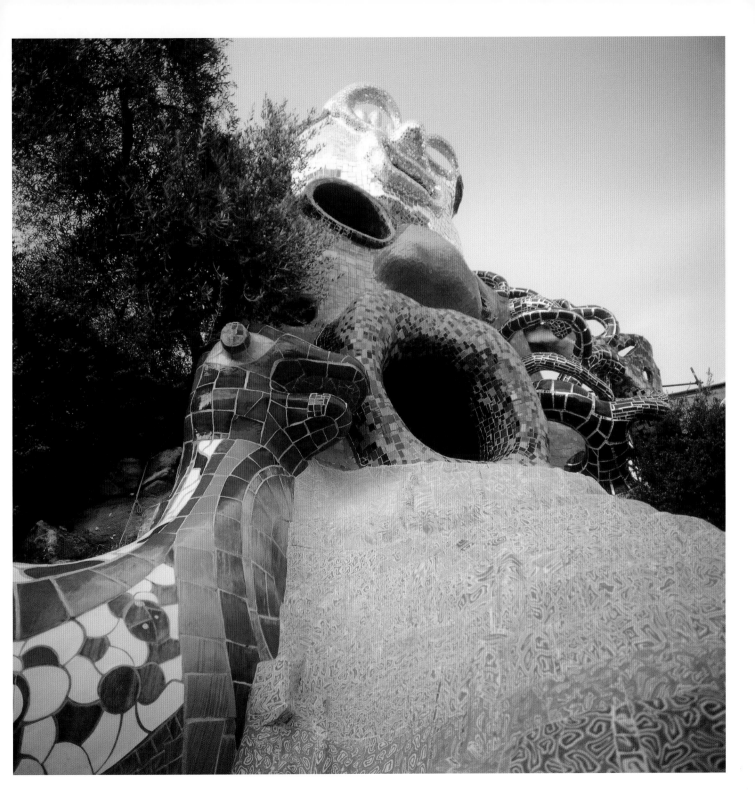

THE WHEEL of fortune

CARD No. X

The wheel of fortune is an age old symbol for the wheel of life. WHAT GOES UP MUST COME DOWN. One day walking in the garden EUREKA! I had the idea of asking Jean Tinguely to make the wheel of fortune into a fountain. The water flowing from the High Priestess.

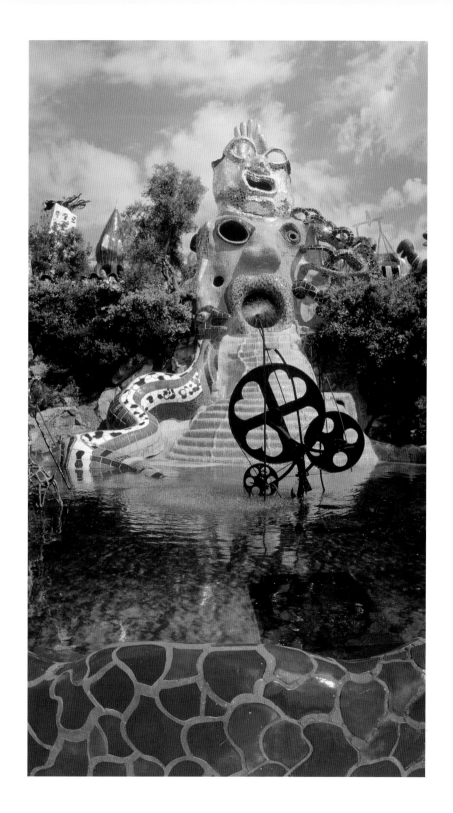

STRENGTH

CARD NO. XI

A frail maiden leads a ferocious dragon by an invisible thread. The Monster the maiden must tame is inside herself. It is her own inner demons she must conquer. Through this difficult task she will discover her own STRENGTH.

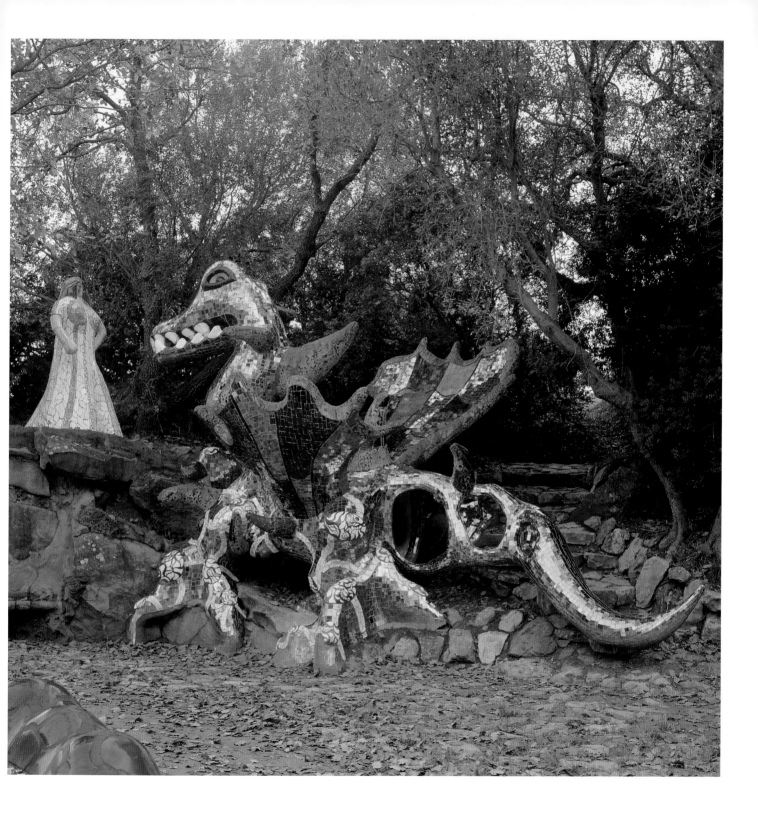

THE SUN

CARD NO. XVIIII

The sun is a life force.
It makes everything grow.
A divinity that can lift
our spirits. I have
conceived of the SUN as
a Bird like those found
in American Indian and
Mexican legends. The bird
is the creature closest to
the sun.

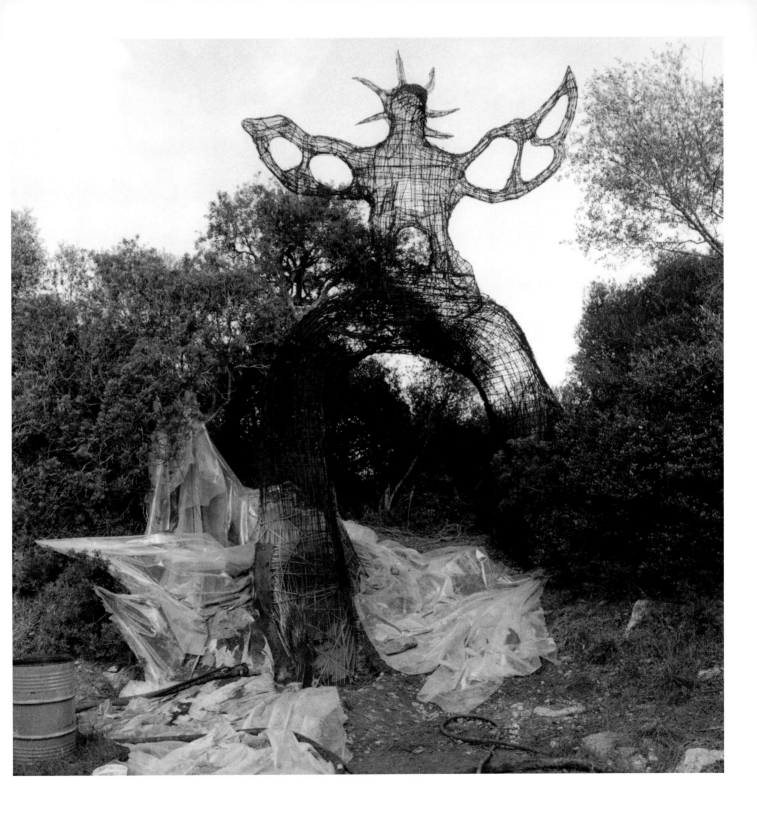

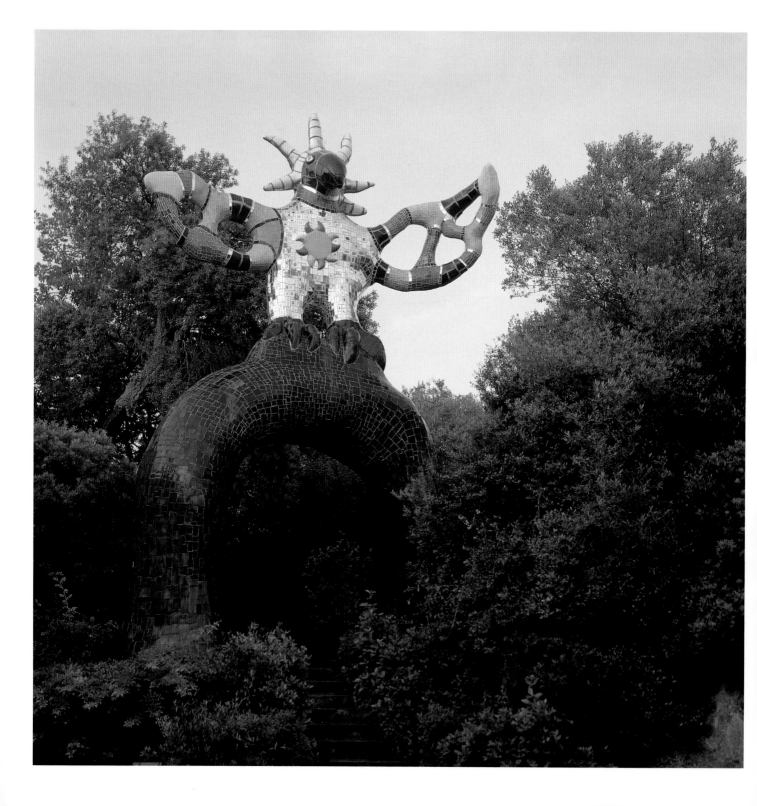

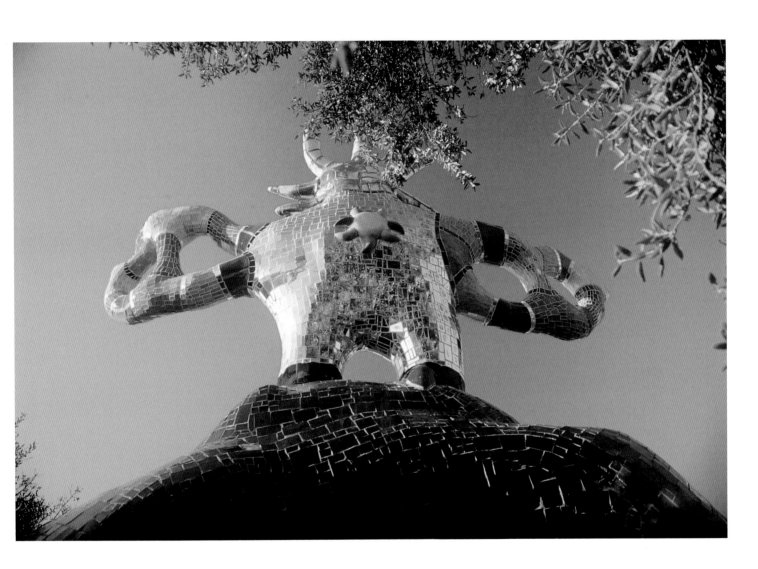

DEATH

CARD NO. XIII

The great Mystery of life. Without death, life would have no meaning. Death the GREAT REAPER, allows new blossoms to grow.

The card of death is a card of Renewal. Being aware of death is a way of not being caught up by the vanities of life.

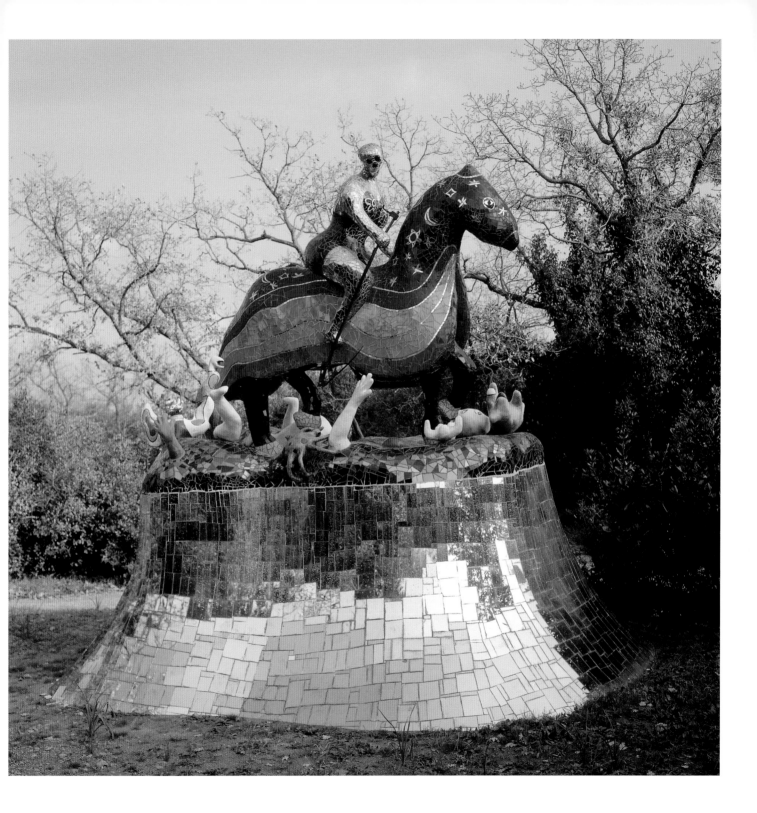

THE DEVIL
CARD NO. XV

Card of Magnetism, Energy, and Sex. The Devil also Represents the loss of personal freedom through addiction of Any kind.

　　It scared me working on this card. I had visions of hundreds of devils swarming around the Sphinx afraid they might attack me.

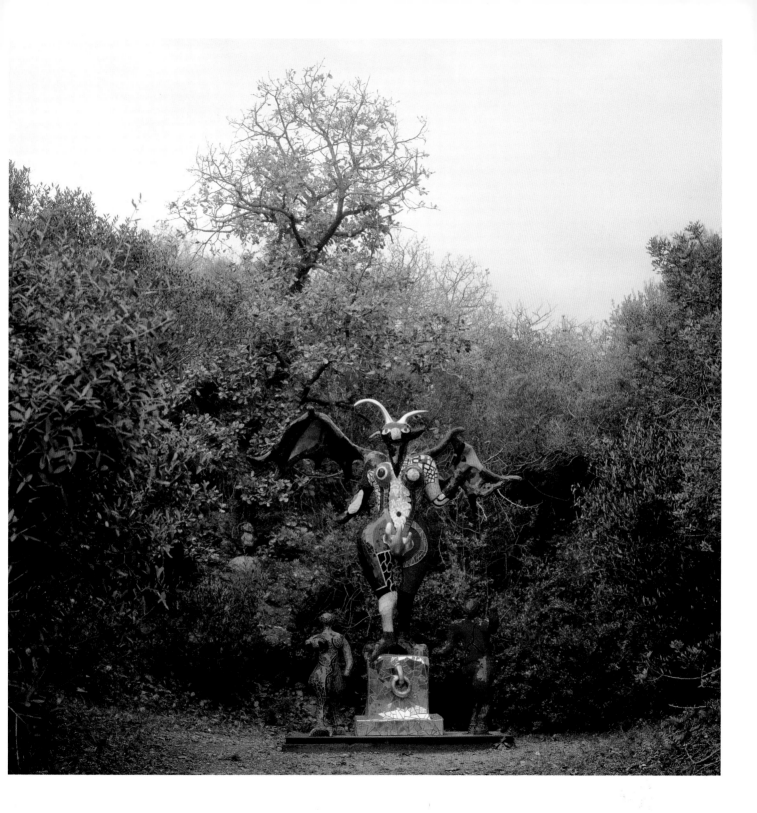

THE WORLD
CARD NO. XXI

The WORLD is the card
of the splendor of interior
life. It is the last card
of the Major Arcana, and
the spiritual exercise of the
game. Within this card lies
the mystery of the WORLD.
It is the answer to the
Sphinx.

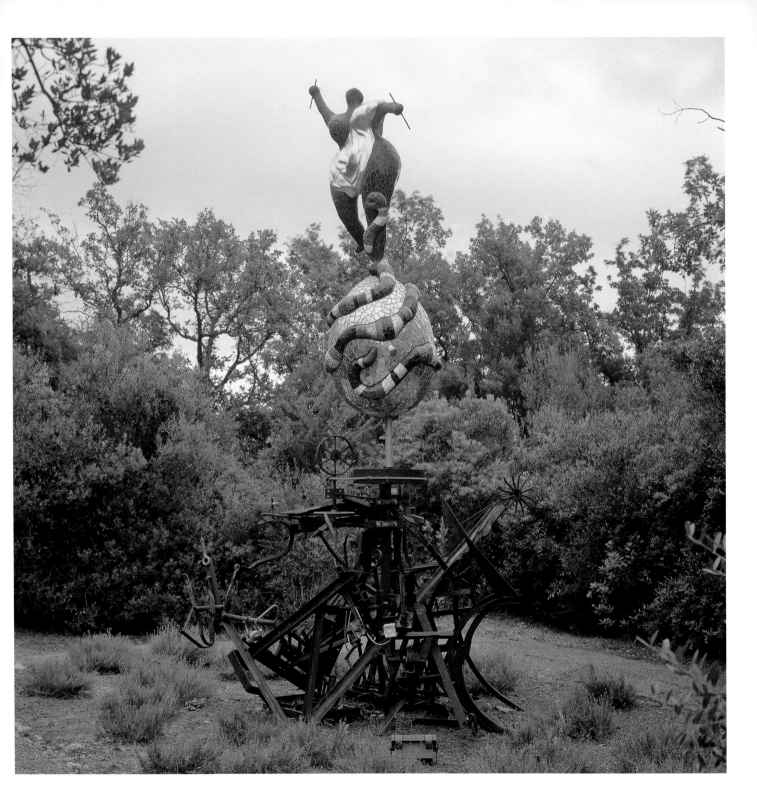

THE Fool

The Fool's number is 0, no number, but for me 0 is a number. The Fool in the tarot deck is as strong as all the other cards put together. Why? Because he represents man on his spiritual quest. Not knowing where he is going, the fool is ready to discover. He is the hero of the fairy tales who appears dim witted but is able to find the "treasure" where others have failed. The Fool has few possessions. He travels light.

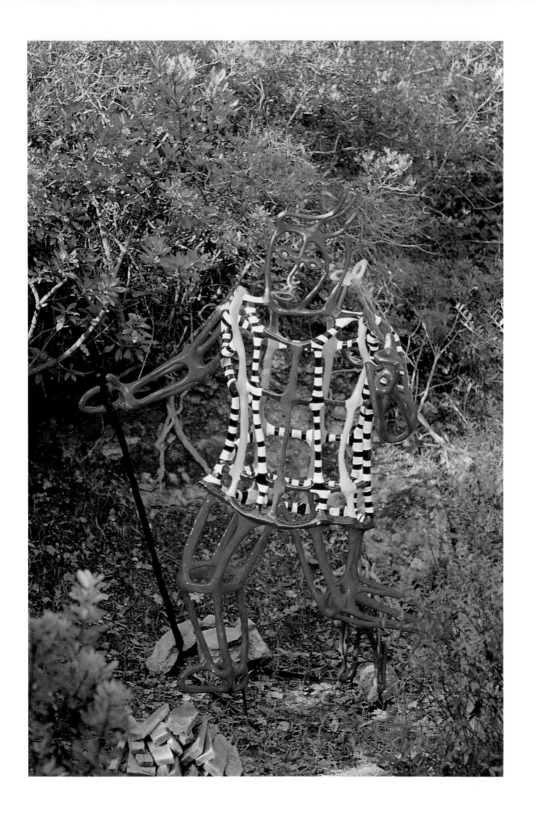

THE HIEROPHANT

CARD NO. V

Through this card one acquires
knowledge of a sacred nature.
He represents for some a teacher,
a guru, a prophet or a Pope.
The Hierophant deciphers mysteries.
It may be a book, a shaman,
a Rabbi or a holy man or
woman.

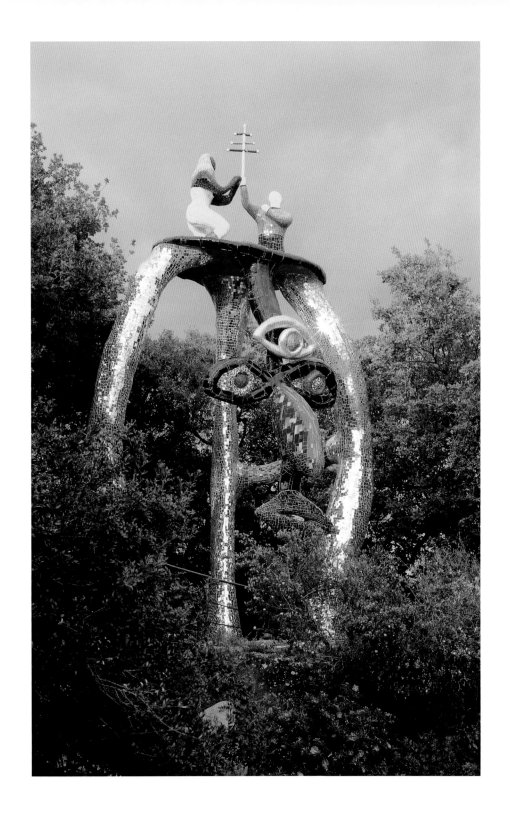

THE HANGED MAN
CARD NO. XII

The hanged man has fascinated
poets and artists throughout
the ages. T. S. Eliot referred
to him in his poem "The Wasteland".
Mysterious and ambiguous, the
Hanged Man is suspended by
his foot. What does that mean?
He is in the position to view the world
upside down, thus in a NEW WAY.
The card also represents Compassion.

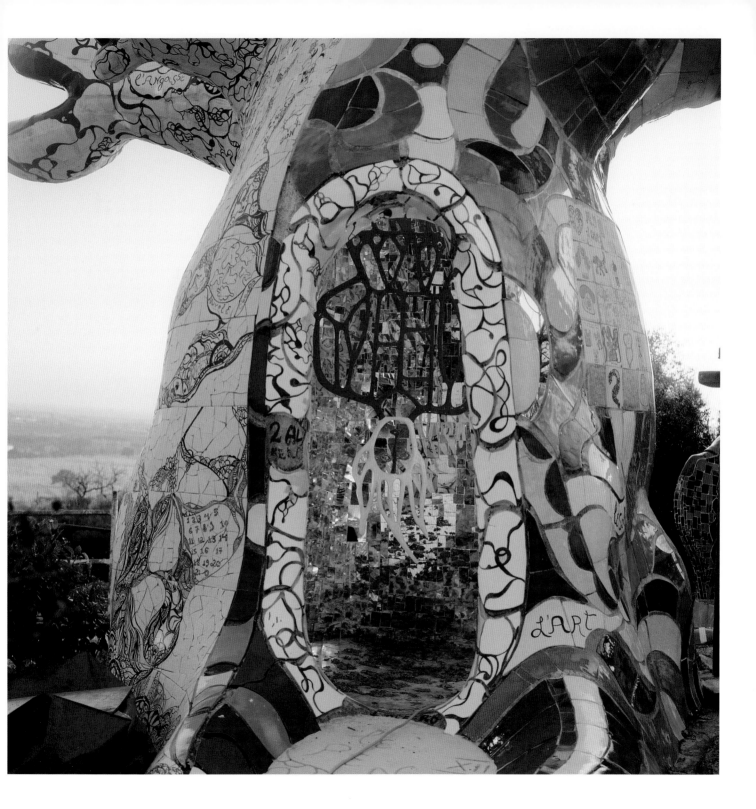

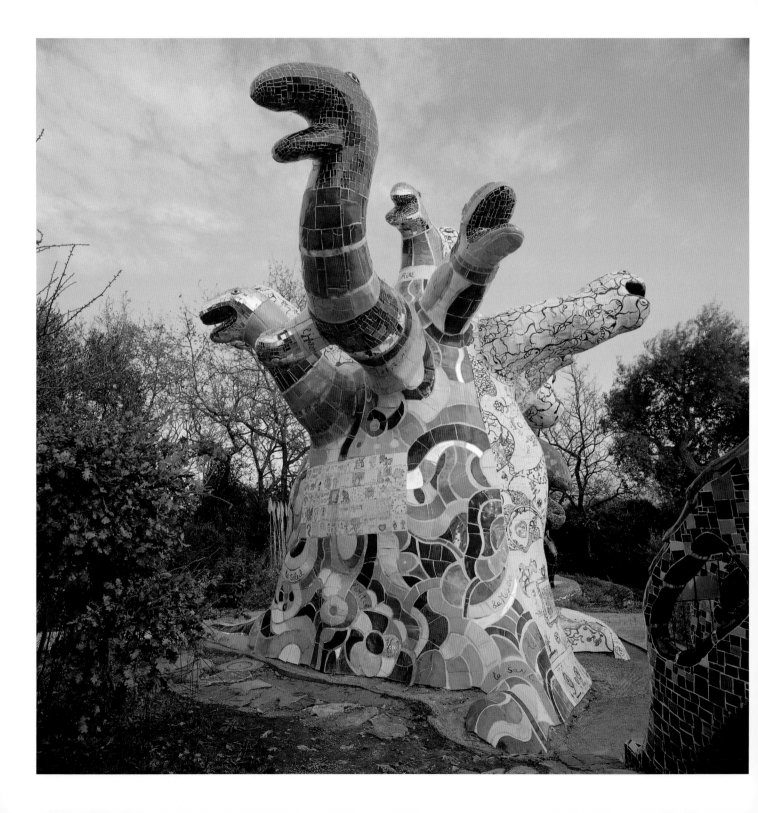

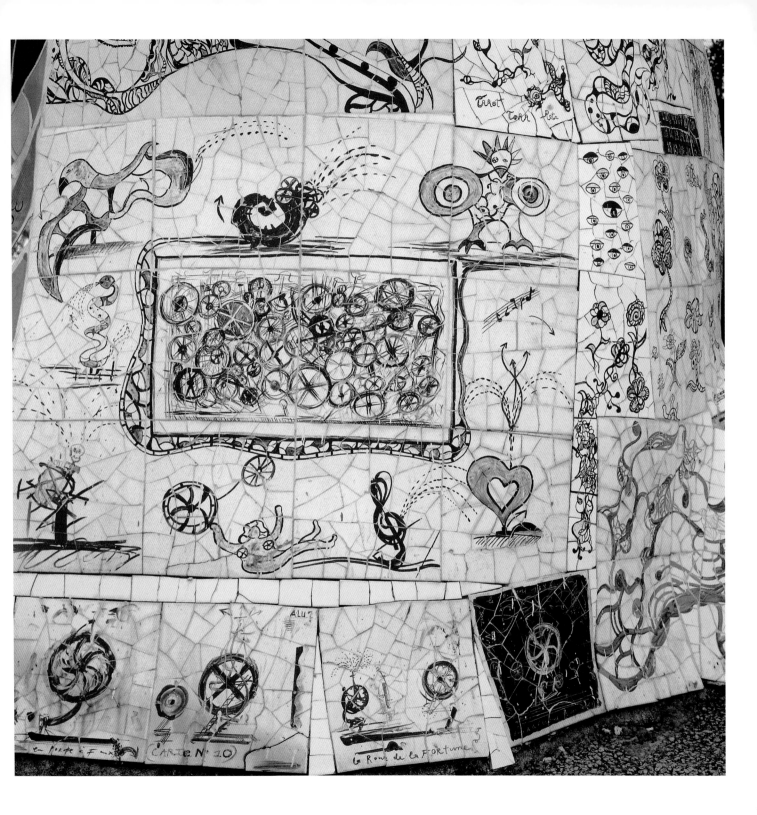

Justice

CARD NO. VIII

Justice implies self knowledge. One needs to acquire an ability to judge oneself, to come to terms with our dark side. With this insight one can judge other people and situations with a compassionate eye. Real justice is not blind, it brings a vision of universality.

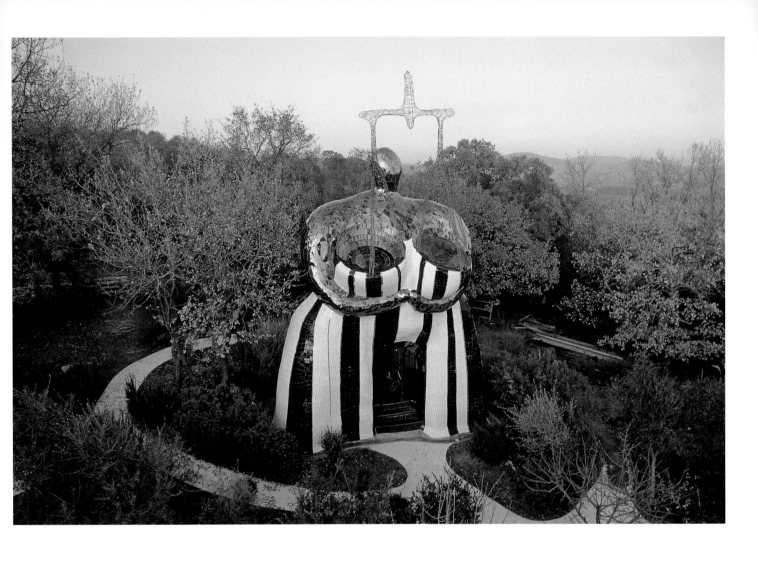

Inside of Justice Jean Tinguely
created a sculpture that represented
Injustice and locked the door with a padlock

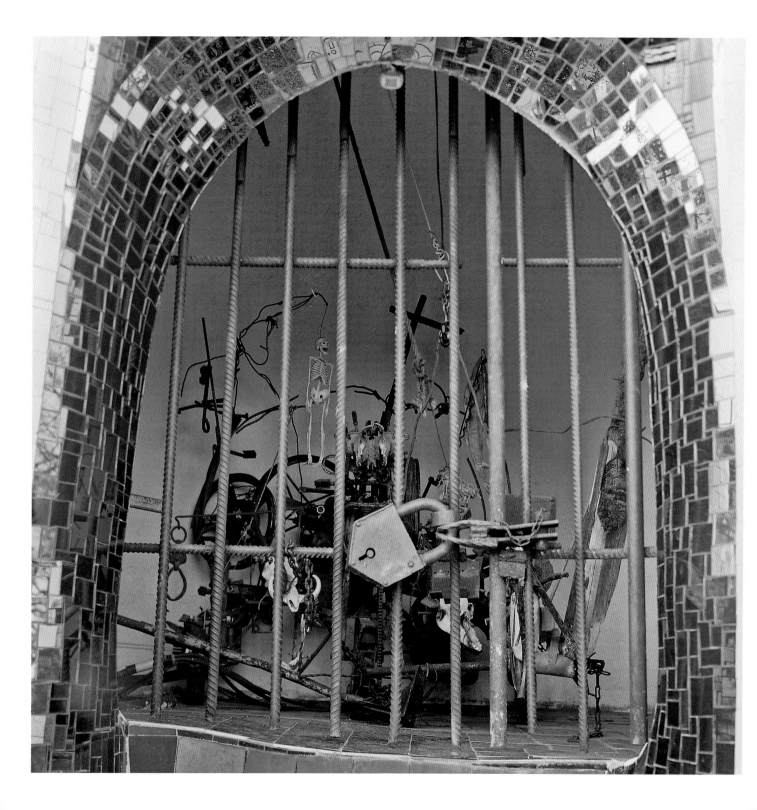

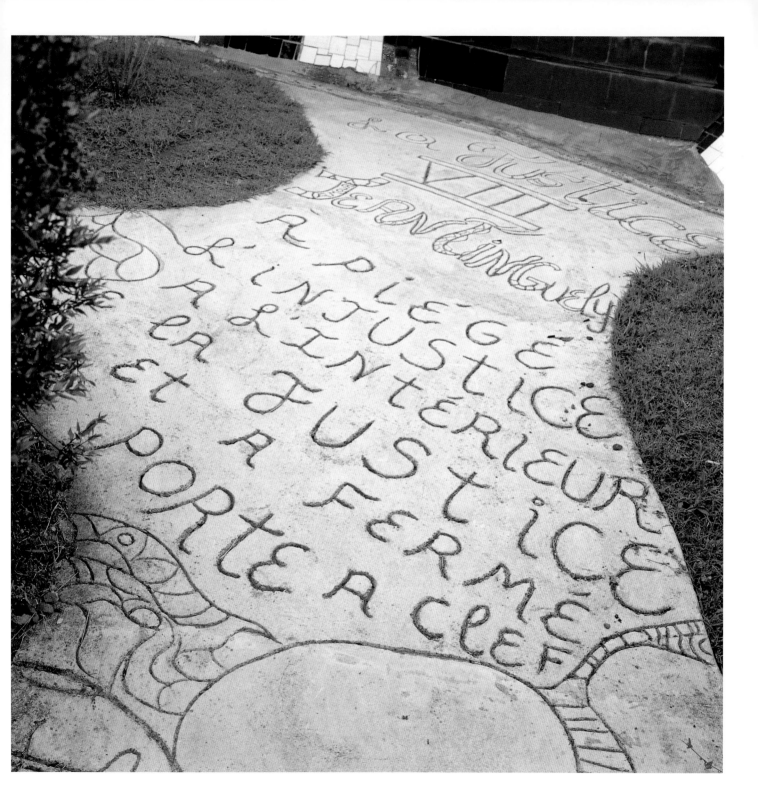

THE CHOICE
(the Lovers)
card NO. VI

Some tarot decks call this card the "lovers". Adam and Eve were the first couple and made the first choice. That is why I have chosen them to represent this card. The card implies there is a wrong and right choice. A mistake can bring one closer to the truth of ourselves.

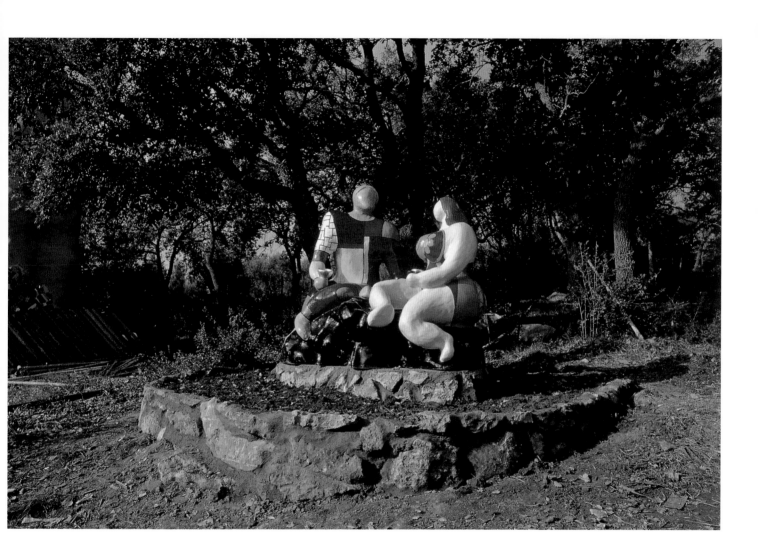

THE HERMIT
CARD NO. VIIII

The Hermit is an experienced
wanderer searching for a spiritual
treasure. The card implies that
the most important lessons
are learned through the heart.

 The Oracle is the female
version of the Hermit. Step
inside her and listen
to her message.

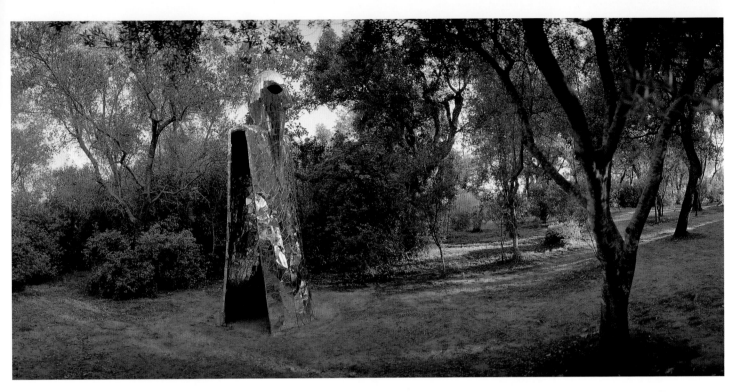
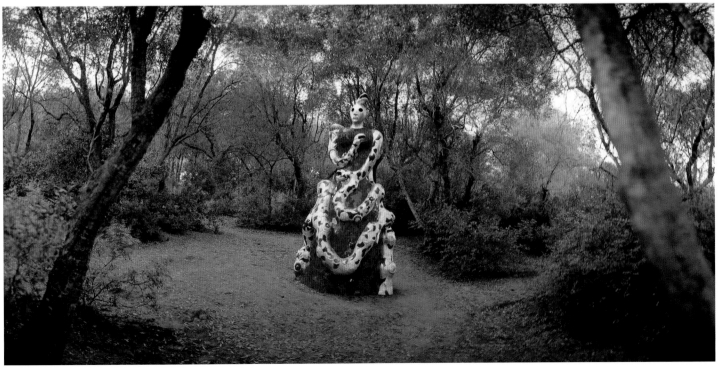

THE FALLING TOWER
CARD NO. XVI

Some call this card the TOWER of Babel. It represents constructions of a physical nature, or of the mind which are not built solidly. The Falling Tower is not only Negative in aspect; it provides a lesson. Complex mental fabrications should fall apart. Break down the mental walls, to see through them.

Jean Tinguely made a symbolic sculpture of "lightning" Ripping the tower apart.

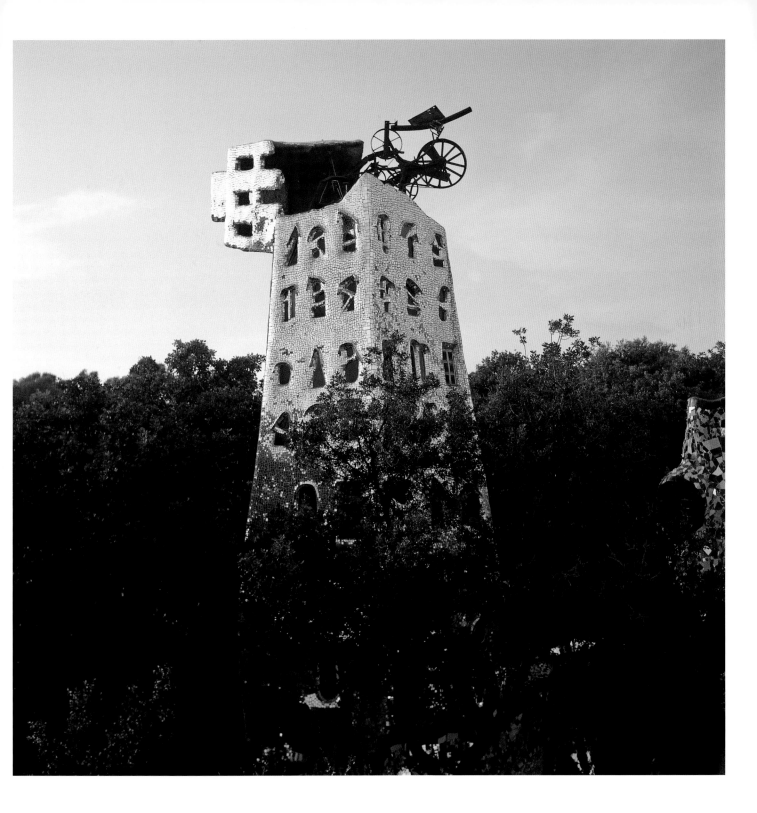

THE EMPEROR

card NO. IV

THE EMPEROR is the card of masculine power, for good or for bad. The Emperor is a symbol of organization and aggression. He has brought us SCIENCE and medicine but also weapons and WAR. He Represents the Patriarch or male protector. He also desires to control and conquer.

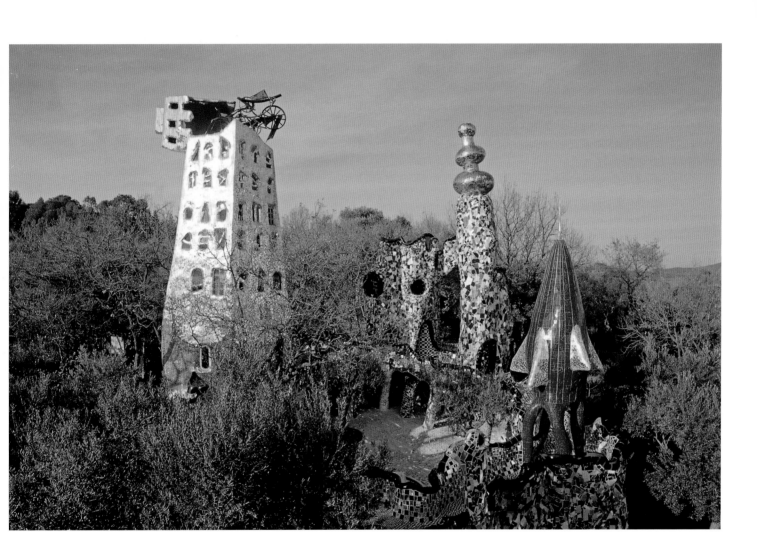

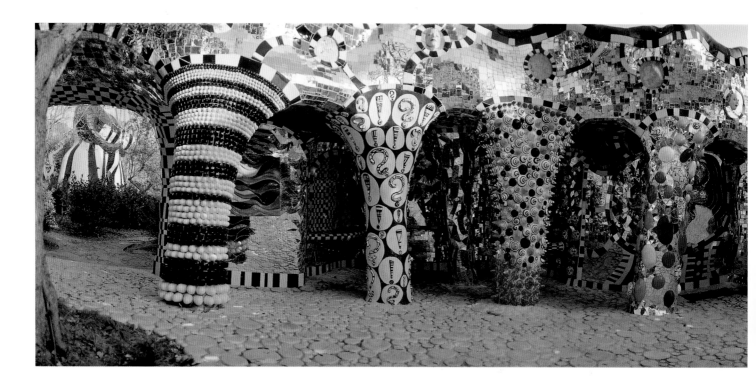
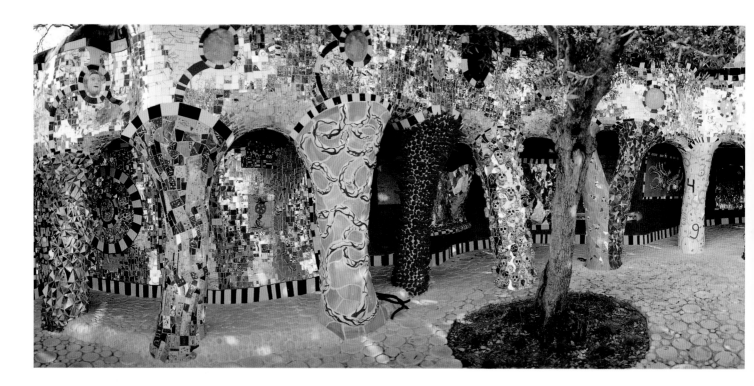

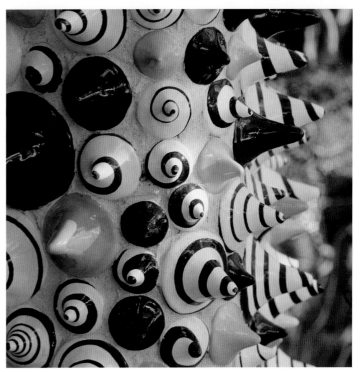

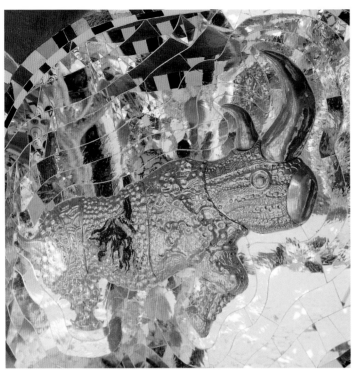
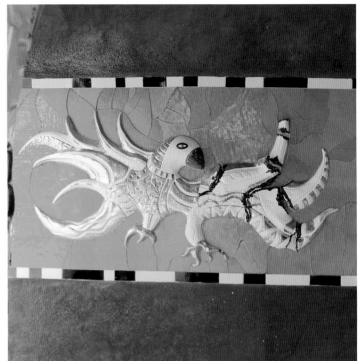
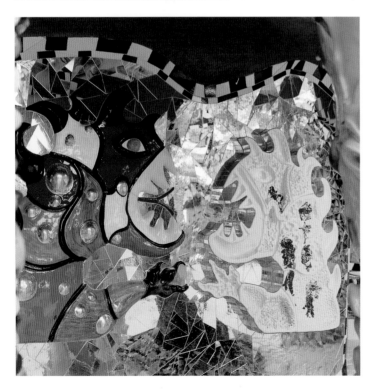
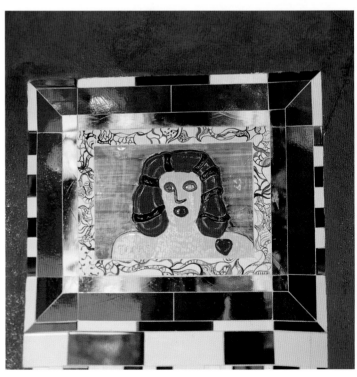

Jean and me talking and dreaming in the tarot garden.

Jean was my ———→
biggest fan. Not only did
he weld over 50% of the
iron chassis of the tarot
but his total enthusiasm
for this esoteric garden
helped me to cope with
the many difficulties I
would encounter making
this garden. Health, finacial, I
financed the garden myself. Lonliness.
Today I see these difficulties
as part of the initiation I had to
go through for the priviledge
of making this garden.

THE EMPRESS

CARD NO. III

THE Empress is THE GREAT GODDESS. She is Queen of the sky. Mother. WHORE. EMOTION. Sacred Magic and Civilization.

The Empress which I made in the form of a Sphinx.

I lived for years inside this protective Mother. She also served for headquarters for my meetings with the crew. It was here we all had coffee breaks. On all she excerted a fatal attraction.

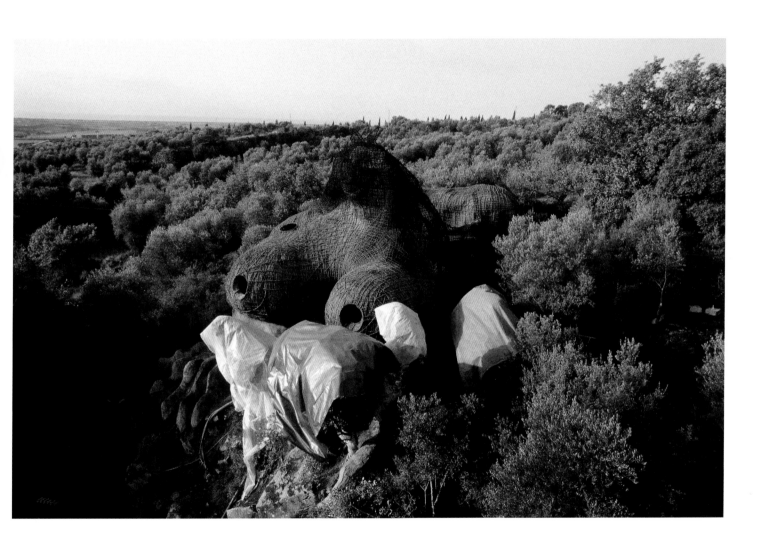

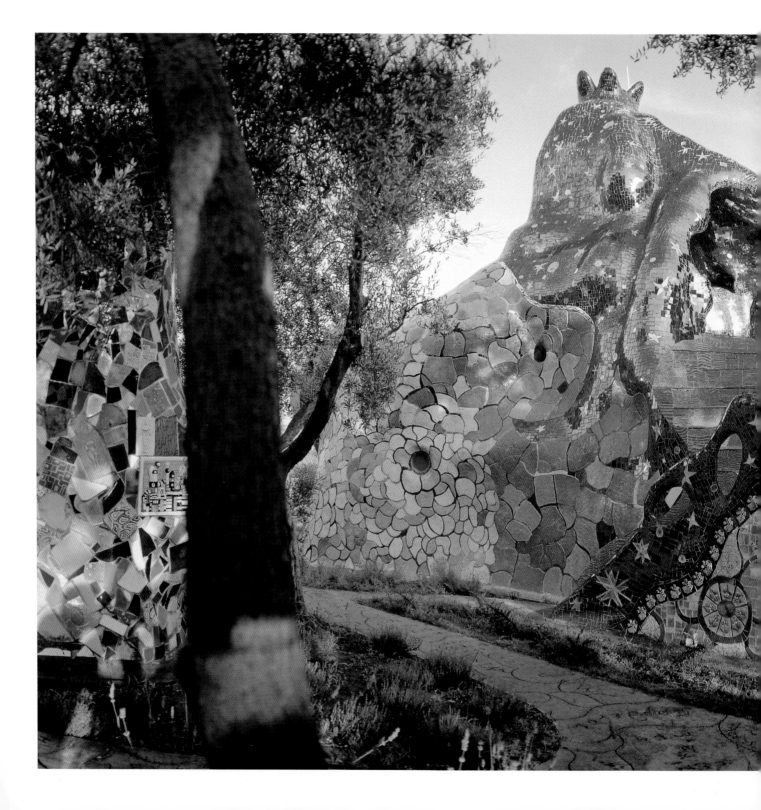

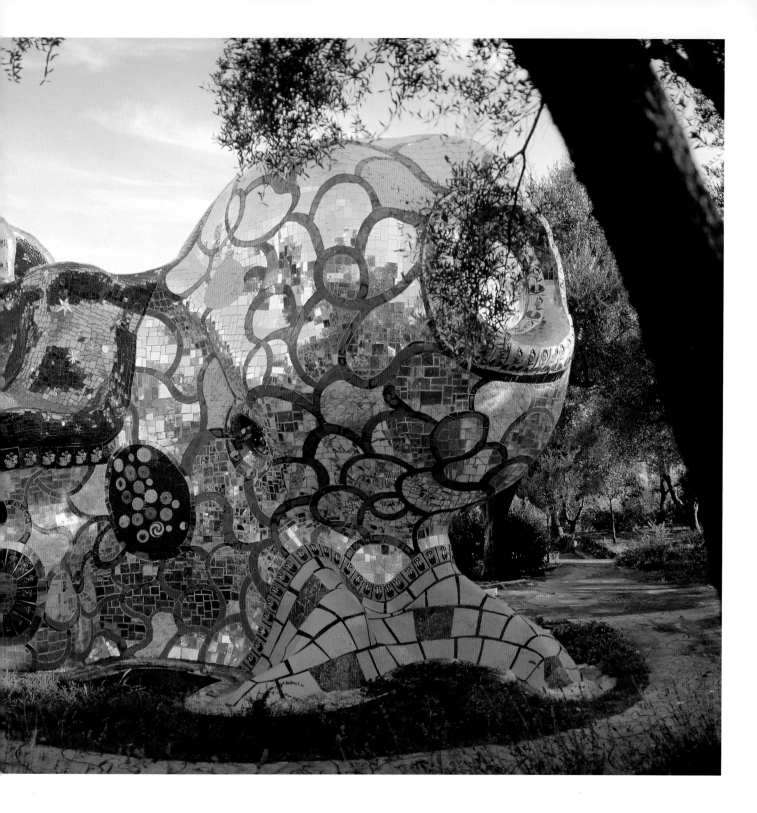

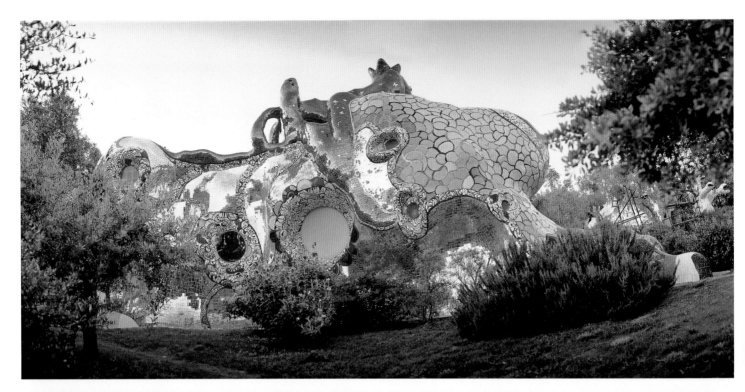

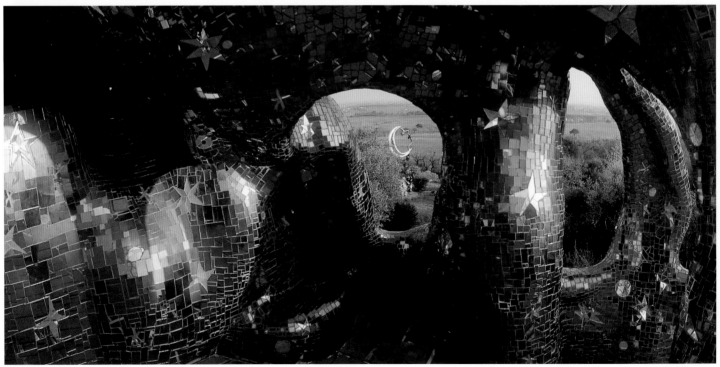

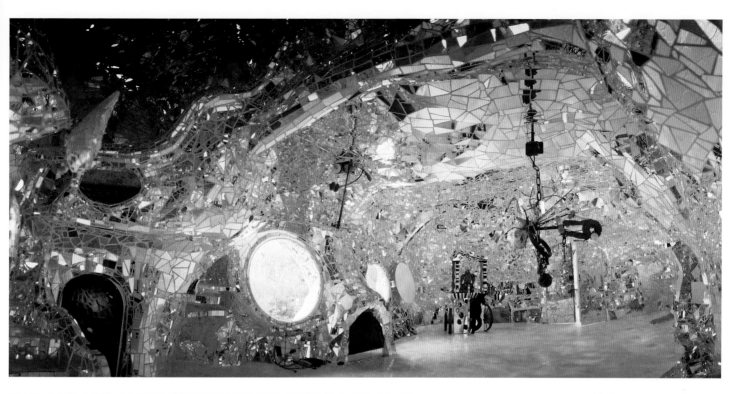
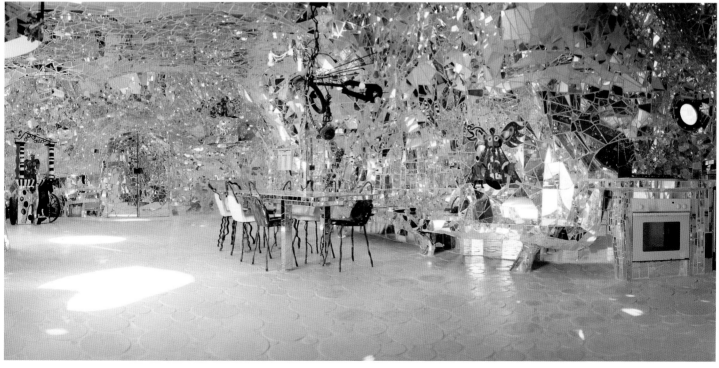

THE CHARIOT

card no. VII

The Chariot represents victory. It is the card of triumph over adversaries, over problems. In the card lies an inherent danger. At the moment of triumph, one must be most vigilant because one is most fragile.

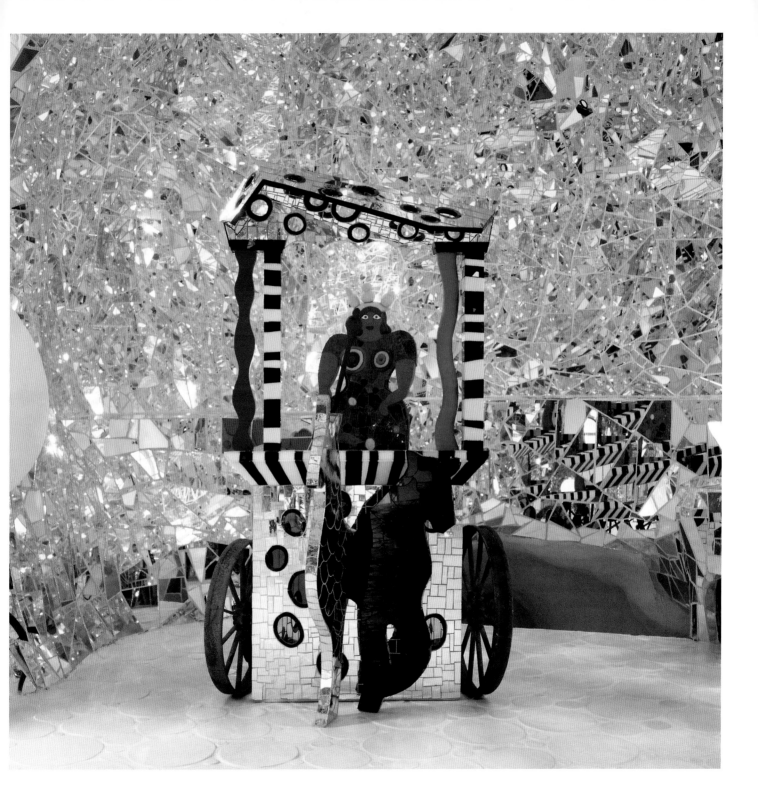

THE STAR
CARD NO. <u>XVII</u>

The STAR carries two jugs
which spill water into a stream -
waters of Renewal. What I love
most about the star is her
completeness. She is a whole being,
Not fragmented as many of us are
in our modern civilization. The
star is in contact and projects
Nature in all its abundance. She
knows the true laws of heaven
and earth.

58

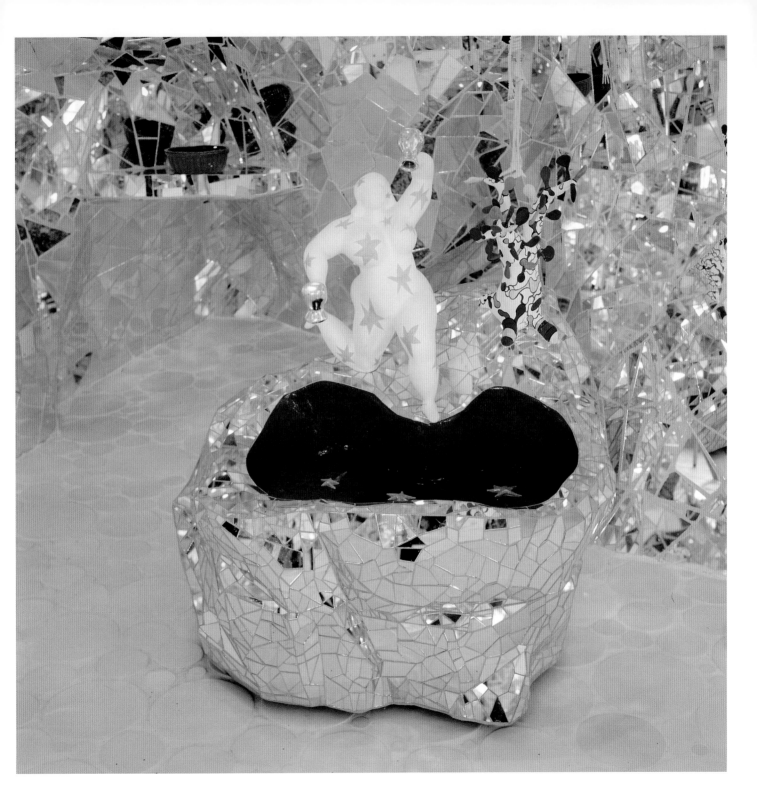

THE JUDGMENT

CARD No. XX

In this card three figures
Rise from a tomb. That of the
child, the middle aged and the
old aged. They represent
the three parts of ourselves
that must merge into ONE.
The angel urges us not to
Judge others but to unite
ourselves, Rise up and become
ONE

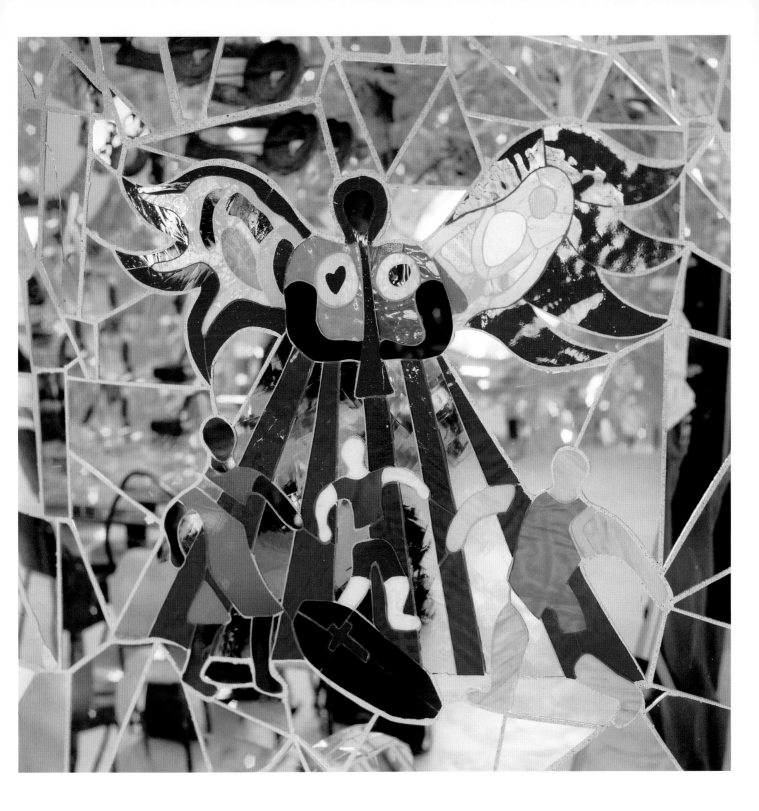

TEMPERANCE

CARD NO. XIIII

I had great difficulty understanding this card. It was too far from my passionate nature. Temperance seemed to me to be a compromise. A middle road. One day the light dawned.

Temperance is the RIGHT WAY. I made an angel of this card which crowns the chapel of Temperance.

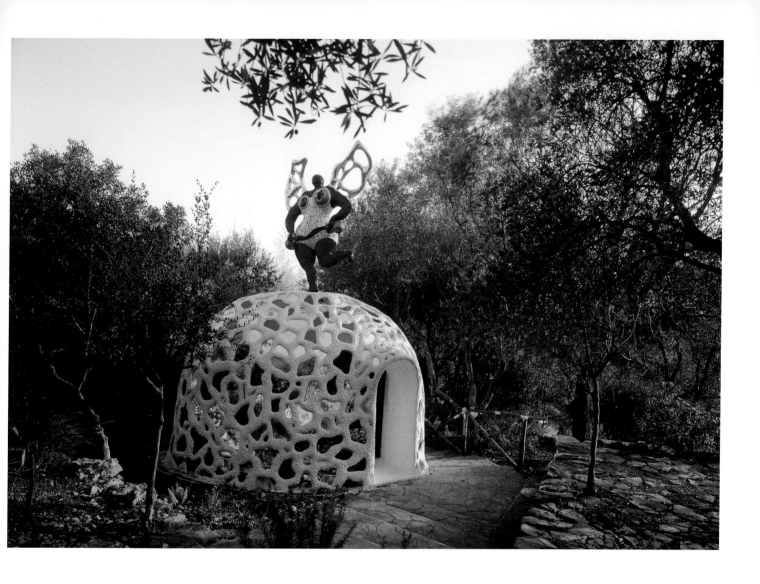

Inside the Dome is a chapel with many mirrors Reflecting the cosmos, flowers and hearts in ceramic and a Black Madonna. It is a magic space.

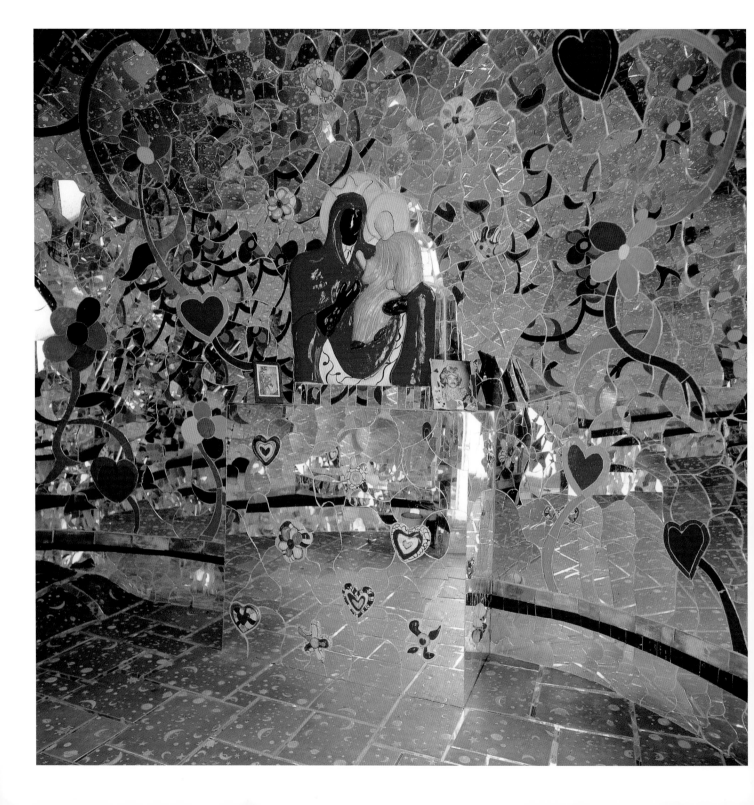

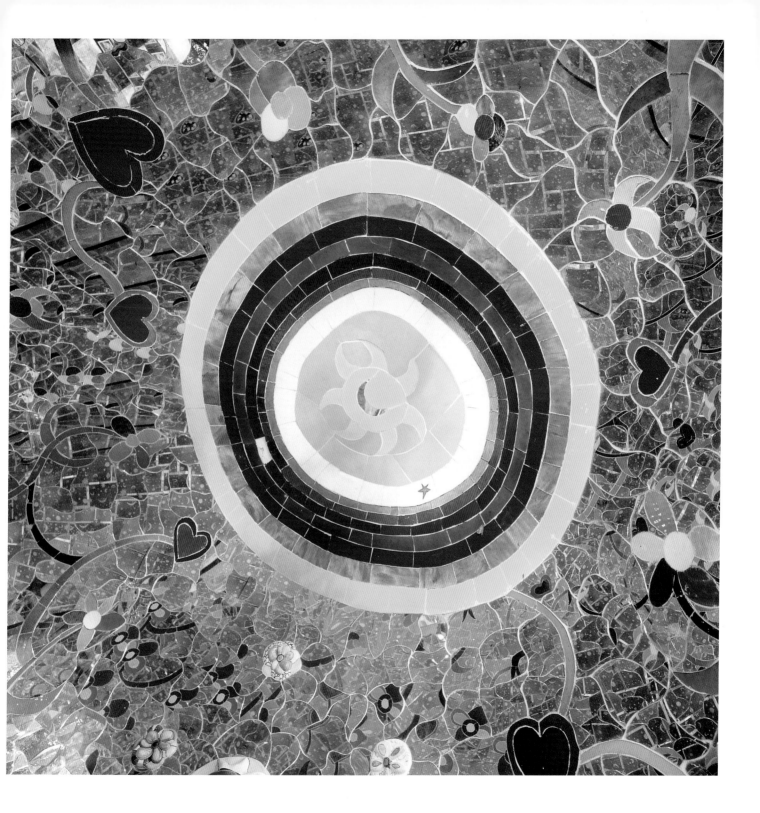

THE MOON

CARD NO. XVIII

The MOON is the card of creative imagination and Negative illusion. The MOON is an interior card - mysterious, enigmatic.

The moon affects the tides of the seas, the menstruation of women, childbirth, and all things connected to the ebb and flow of water. The card of the Moon can be perilous or offer great imaginative power.

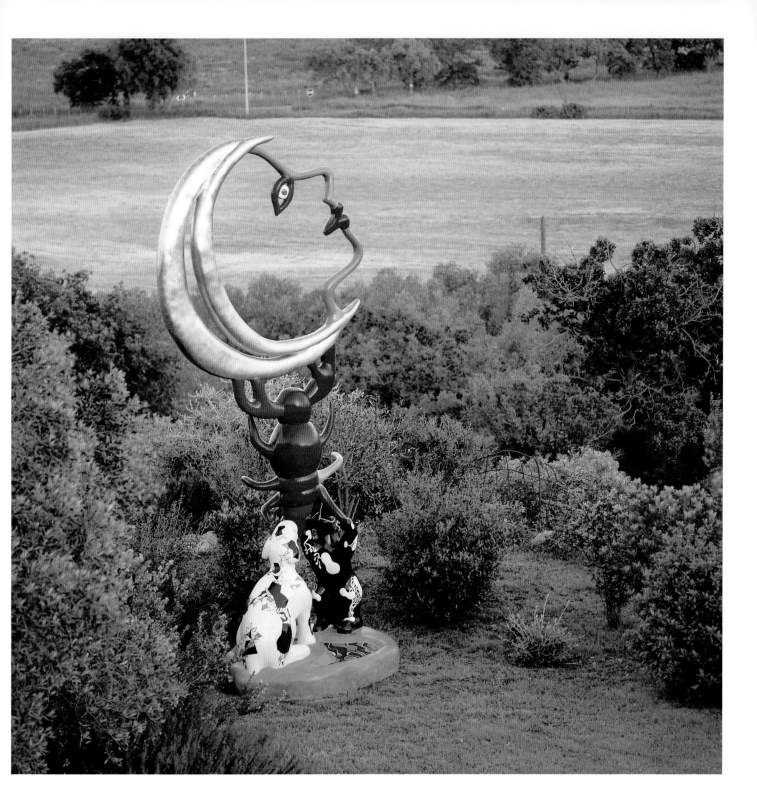

I asked my friend MARIO BOTTA to make the entrance of the garden in CONTRAST to what was inside.

Mario made a masculine fortress-like wall of local stones which marks clearly the seperation of the world without and the world within. The wall symbolizes for me a protection like the dragon who protects the treasure in fairy tales.

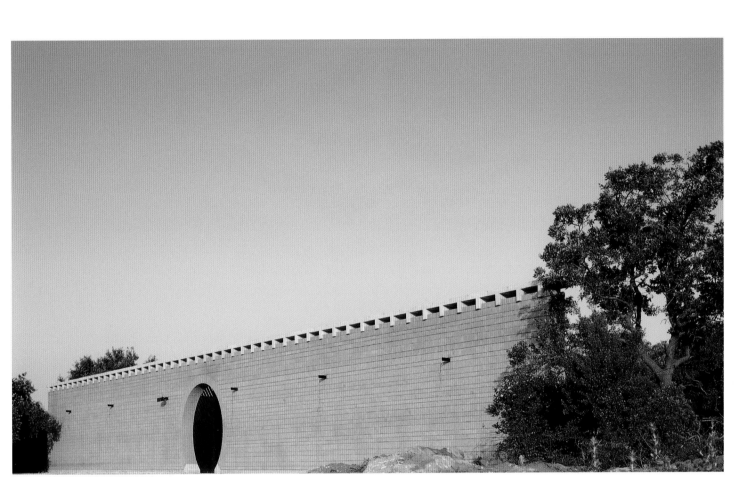

THE CARDS

If life is a game of cards, we are born without knowledge of the rules. Yet we must play our hand.

Is the tarot only a card game, or is there a philosophy behind it? I am convinced that the cards contain an important message. The origins of the tarot are shrouded in mystery. It seems that the high priests of ancient Egypt transmitted their secret knowledge by means of pictorial symbols and that these symbols were the twenty-two Major Arcana of the tarot pack. It is believed that Moses brought these cards with him to Israel, having recieved them from the high priests of Egypt. That explains why the hebrew cabala is linked to the twenty-two cards (tarot – tora – rota).

The first tarot cards we know of were found in Italy, designed by Bonifacio Bembo in the fifteenth century for the Visconti family of Milan. Later the cards became popular at all levels of society. Used as normal playing cards, they eventually lost their original significance. It was not until the eighteenth century that Antoine Court de Gébelin rediscovered their esoteric meaning. These same cards, with the same symbols, were and are found ail over the world.

The Major Arcana are engraved in stone inside the dome of Siena. These depictions date from the fourteenth and fifteenth centuries, a period when many church leaders, including some popes, were interested in al chemy and astrology. This explains the presence of tarot symbols in the dome of Siena. Andrea Mantegna too, was interested in the tarot and made some beautiful engravings of its symbols. They are now in the Bibliothèque Nationale in Paris.

The tarot has given me a greater understanding of the spiritual world and of life's problems, and also the awareness that each difficulty must be overcome, so that one can go on to the next hurdle and finally reach inner peace and the garden of paradise.

MATERIALS, TECHNIQUES & COLLABORATORS

The enlargement of my models was made perfectly with a medieval eye, by Jean Tinguely and Doc Winsen. All of the monumental sculptures' armatures were made from welded steel bars, formed by brute strength on the knees of the crew. The first crew who welded in the garden were: Jean Tinguely, Rico Weber and Seppi Imhof. They built The Sphinx, The High Priestess and The Magician. The Pope was started by Doc Winsen and finished by Jean Tinguely, it was Jean's favorite sculpture of all the garden.

The second half of the Tarot Garden, The Emperor's Castle, The Sun, The Dragon (Strength), and The Tree of Life (The Hanged Man) were welded by Doc Winsen, a Dutch artist. Doc was assisted by Tonino Urtis.

Next came Ugo, the postman, who began by making stone paths, and then graduated to putting the wire mesh on the steel structures to receive the cement. Later, Ugo would ask me to try his hand at putting the mirrors on the sculptures. He has become a poet of putting on mirrors. He's always afraid there would be no more work for him. I have made the solemn promise that I would make sure that there was always something new to do each year, and if I run out of ideas, I will make a wall of china around the garden that should take several generations to finish.

Once the steel armatures were finished and the wire mesh was stretched over them, they were ready for the gunite cement which was sprayed on. The sculptures then had a melancholy look with a certain sad beauty. My purpose, however, was to make a garden of joy. The finishing of the cement was later done by hand with Marco Iacotonio, a very beautiful and difficult young man.

Early on, I chose Tonino Urtis to be head of the work crew, even though he had no experience; he had been an electrician before. I have always used my instinct in my choices, not my brain, and very often these choices proved right.

I then asked Ricardo Menon, my personal assistant, collaborator and great friend who had come with me from Paris, to find me a ceramist. A few days later Ricardo presented me with Venera Finocchiaro.

Venera would become the ceramist of the garden. It was total immersion. She lived at the garden and responded to my asking her to do new things in ceramics that had not been done before. The magnificent work she produced speaks for itself. She had several assistants, the main ones being Paola, Patrizia and Gemma. Sometimes the whole crew would be up at the ovens working too. After Venera left, the crew continued with the ceramics.

The twentieth century was forgotten. We were working Egyptian style. The ceramics were molded, in most cases, right on the sculptures, numbered, taken off, carried to the ovens, cooked and glazed, and then put back in place on the sculptures. When ceramics are cooked there is a 10% loss in size, so the resulting empty space around the ceramics were filled in with hand cut pieces of glass. This was done by a variety of different people – the main ones being Marco Iacotonio, Tonino Urtis, Ugo Celletti and Claudio Celletti.

The smaller pieces in the garden were made by me in Paris, France with my assistant Marcelo Zitelli. They were then fabricated in polyester by Robert Haligon and his sons, Gerard and Olivier. Temperance, Adam & Eve (The Choice), The World, The Hermit, The Oracle, Death and The Hanged Man were the pieces they fabricated. They were later covered in glass mosaic from Murano, Czechoslovakia and France by Pierre Marie Le Jeune and his wife Isabelle.

Pierre Marie Le Jeune, who had painted the Stravinsky fountain with me, came to the Tarot Garden and fell in love with it. He would return year after year. His specialty became cutting mirrors with a keen eye for innovative work. Pierre Marie and his wife, Isabelle, also did the glass work on the sculptures of The Devil, The World, Death, The Hermit and The Oracle.

The administrative work and tending to various problems of the garden is managed by Gigi Pegoraro and Paola Aureli. The knight of the garden has been Jean Gabriel Mitterrand who came every time there was a problem to help us resolve it. In the last years, the people that have remained have been Tonino Urtis, Ugo Celletti, Marco Iacotonio and Claudio Celletti. We all share an immense enthusiasm for the garden and have grown to be like a family. Recently Gian Piero Ottavi joined us to look after the grounds

of the garden. I have chosen to respect the natural habitat of the region. The dialog between nature and the sculptures is a very important part of the garden.

The artists who have participated with their special works in the garden are: Alan Davie who painted a magical space inside the Magician. Pierre Marie Le Jeune made some ceramic benches that are integrated into the garden, they are a very popular feature where people love to sit and watch the fountain. He also made some chairs in The Sphinx, and decorated the boutique. Marina Karella made the sculpture which stands inside the High Priestess. Jean Tinguely made a machine representing lightning striking the Tower of Babel, The Wheel of Fortune in the form of a fountain, a sculpture called Injustice which is locked inside of Justice, and The World in collaboration with me. Jackie Matisse has made alchemical glass containers for sacred waters. Giulio Pietromarchi, whose photographs are featured in this book, was sixteen years old when I met him. He was my neighbour. He started photographing the garden very near to its beginnings and has never stopped.

So many people have helped with the making of the gardens, and I am thankful to them all, but for lack of space, I have been able to mention only the most essential and committed collaborators.

BIOGRAPHY

1930 Niki de Saint Phalle was born in Neuilly-sur-Seine, France. She was brought up in New York where her family immigrated in the late twenties.

1948–1955 She begins to paint. She marries the writer Harry Mathews with whom she will have two children Laura and Philip. The Mathews take up residence in Europe (Paris, Mallorca and Nice). In Barcelona she discovers the architecture of Gaudi which will profoundly influence her later work.

1956 First show of paintings in St. Gallen, Switzerland. She begins a series of assemblage paintings made with found objects embedded in plaster and paint.

1960–1964 The beginning of a long and productive collaboration with the sculptor Jean Tinguely. She starts the shooting paintings, a series of actions in which the public or the artist herself shoots with a 22 caliber rifle at the plaster reliefs inside of which are plastic bags of paint which explode under the impact of the bullets. Niki becomes a member of the Nouveaux Réalistes. Participates with Robert Rauschenberg, Jasper Johns and Tinguely in a concert performance of "Variations 2" by John Cage with David Tudor performing on the piano, presented at the American Embassy in Paris.

1965–1970 Shows her first sculptures of "Nanas" in New York and Paris. With Tinguely and Ultvedt constructs the "Hon", a gigantic pregnant Nana laying on her back for the Moderna Museet of Stockholm. The "Fantastic Paradise", an assemblage of nine sculptures of Saint Phalle's and Tinguely's for Expo '67 in Montreal. Starts creating architectural live-in sculptures in the south of France for Rainer von Diez. Collaborates with Tinguely for the making of a monumental sculpture in Milly-La-Forêt, "Le Cyclop".

1972–1975 In Jerusalem's Rabinovitch Park constructs a monster sculpture for children, the "Golem". In Knokke-le-Zout, Belgium, constructs a play house for children "The Dragon" for the Nellens family. Writes and directs her first film "Daddy" in collaboration with Peter Whitehead. Permanently installs three monumental "Nanas" in the center of the city Hanover, Germany. Writes and directs a film "Camelia and the Dragon".

1979–1996 Her major work during this time is the "Tarot Garden" in Garavicchio in the south of Tuscany. A group of 22 monumental sculptures, some of them living spaces, which are inspired by the 22 major arcana. They will be made in cement and covered in mosaic, mirrors, glass and ceramic.

1980–1986 Retrospective of Niki's at the Pompidou Center in Paris. Collaborates with Tinguely on the "Stravinsky Fountain" in front of the Pompidou Center. Starts a perfume to finance the construction of the Tarot Garden. Installs a monumental sculpture the "Sun God" at the University of California in San Diego, USA. Writes and illustrates a book with Professor Silvio Barandun, "AIDS: You Can't Catch It Holding Hands", which is translated and published in five languages.

1987–1993 President Mitterrand commissions Tinguely and Saint Phalle to make a fountain for the Town Square of Château-Chinon where he had been mayor. She makes a series of kinetic reliefs, or paintings in movement, called the "Exploding Paintings". A retrospective of Saint Phalle's work is organized by the Kunst- und Ausstellungshalle of Bonn, Germany, by Pontus Hulten, which travels to the McLellan, Glasgow, Scotland, to the Museum of Modern Art in Paris, and the Museum of Art and History of Fribourg, Switzerland. Permanent installment in Duisburg, Germany, of a large sculpture called "Bird in Love".

1994–1997 Moves to and works in California. Makes a series of 8 silk-screens called "California Diary". Collaborates with the architect, Mario Botta, on a project for the con-

struction of "Noah's Ark" in Jerusalem, Israel. Makes a dragon play house for children in stone, glass and ceramic in Southern California for friends. Is preparing a ten meter "Protecting Angel" for the Zurich Station of CFS Swiss Railroad.

1998 – 2002 Starts design work and plans for "Queen Califia's Magical Circle", a sculpture park in Kit Carson Park, San Diego, drawing much of the imagery from Native American culture. Accepts commission to redesign and ornament three rooms in the historic Grotto built in Hanover's Royal Herrenhausen Garden. Niki dies on 21 Mai 2002 in La Jolla, California. Members of her staff oversee final work on "Queen Califia's Magical Circle" and Hanover projects. The Niki Charitable Art Foundation, a non-profit organisation, is established.

© Copyright by Niki de Saint Phalle and Giulio Pietromarchi, 1997
Production and distribution: Benteli,
imprint of Braun Publishing AG, Salenstein, Switzerland
Reprint 2022
ISBN 978-3-7165-1092-6 (softcover)
ISBN 978-3-7165-1834-2 (hardcover)
www.benteli.ch